transferred to Susie Davis Humphries
6 April 2004

Love,
Milton

OSSABAW

EVOCATIONS OF AN ISLAND

OSSABAW

EVOCATIONS OF AN ISLAND

JACK LEIGH JAMES KILGO ALAN CAMPBELL

THE UNIVERSITY OF GEORGIA PRESS ATHENS & LONDON

© 2004 by The University of Georgia Press
Athens, Georgia 30602
Photographs © 2004 by Jack Leigh
Essay © 2004 by James Kilgo
Paintings © 2004 by Alan Campbell
All rights reserved
Designed by Sandra Strother Hudson
Set in Adobe Garamond with Cresci display
Printed and bound by Pacifica Communications
The paper in this book meets the guidelines for permanence
and durability of the Committee on Production Guidelines
for Book Longevity of the Council on Library Resources.
Printed in Korea
08 07 06 05 04 C 5 4 3 2 1

Library of Congress Cataloging-in-Publication Data
Leigh, Jack, 1948–
Ossabaw : evocations of an island / Jack Leigh, James Kilgo, Alan Campbell.
p. cm.
ISBN 0-8203-2642-9 (alk. paper)
1. Ossabaw Island (Ga.)—Pictorial works. 2. Ossabaw Island (Ga.)—Description and travel.
I. Kilgo, James, 1941– II. Campbell, Alan, 1950– III. Title.
F292.C36L45 2004
917.58'724—dc22
2003025650

British Library Cataloging-in-Publication Data available

CONTENTS

Acknowledgments

Foreword by John Lane

PHOTOGRAPHS BY JACK LEIGH

ESSAY BY JAMES KILGO

PAINTINGS BY ALAN CAMPBELL

ACKNOWLEDGMENTS

The authors gratefully acknowledge the support of the following sponsors,
who helped make this publication possible:

MR. AND MRS. ROBERT W. GROVES III

HILBURN O. HILLESTAD

JAMES F. JACOBY

SALLY AND HENRY MINIS

We also thank
Ben Beasley; Richard Boaen; Dr. and Mrs. Anthony Costrini; Michael and Mary Erlanger;
Ann Foskey; Marie Garrison; Michael and Linda Ingram; Susan A. Laney; Jeff Mormon;
The Ossabaw Island Foundation: Zelda Tenenbaum, Elizabeth DuBose, and Jesse Timberlake;
Roger Parker; Donna Rice; Katie Showalter; and Gordon Varnedoe.

This book is dedicated to Sandy West,
whose vision for Ossabaw has inspired countless others to dream.

FOREWORD

JOHN LANE

Ecologists speak of ecotones, areas of transition where two different natural communities share some characteristics but possess their own characters as well. Field scientists find ecotones quite rich for botanizing or studying snakes or birds, creatures who thrive on the abundant life found at the edges of intersecting habitats.

The metaphors of science can offer artists the perfect points at which to begin to understand our relationship to the natural world. Like scientists and wildlife, artists search out the edges. We are drawn to them in the way a feeding heron positions itself where marsh becomes maritime forest. Artists flourish at the edges like island deer or turkeys working the dune edges for forage.

Jack Leigh, James Kilgo, and Alan Campbell are all southern artists who have found inspiration and sustenance on Ossabaw Island, an isolated barrier island off the coast of Georgia. They all have enjoyed extensive stays on Ossabaw (Jack Leigh calls his time on the island "pure photographic time") that have led to the photographs, essay, and paintings that follow. This book forms a southern ecotone in its own way. The three artists and their work establish an "edge community" by way of their collaboration. As we view the images and read Kilgo's essay we watch an island rise from the sea of their collective imagination.

A southern barrier island such as Ossabaw, which this collection celebrates, is a land of natural edges—sea and land, sea and sky, sky and land. Rather than one place—an island—Ossabaw is actually many places. Sometimes these places change at our feet—microhabitats—and have to be called by more and more particular names. Other times whole stretches of interior island space can be caught in a single name—marsh, live oak stand, freshwater pond.

It's hard sometimes in a landscape of shifting perspectives such as Ossabaw to get sense and bearing. Edges do that to people's imaginations. Artists thrive in the chaos of

so much stimulation. Edges turn us around, ask us to look in many directions, attend to the moments and to what's both close by and far afield.

Add the human element of historical time to the idea of edge environments and things really start to spin. Human history often happens in the places where landforms come together. Beach and mountain property are both rich in the drama of our centuries of "ownership."

Ossabaw is not short on drama. How could it be? It's twenty miles south of Savannah, but it might as well be a million miles away from the world of *Midnight in the Garden of Good and Evil*. The island has nine thousand acres of high ground and sixteen thousand acres of tidal marshes, making it the third largest of Georgia's sea islands. It's bounded on the south by St. Catherines Sound, on the east by the Atlantic, on the north by the Ogeechee River and Ossabaw Sound, and on the west by an extensive marsh. Biologically rich and diverse, the island offers—if kept undisturbed by humans—nesting ground for loggerhead turtles and important feeding areas for many wintering shorebirds and seabirds, some—such as the long-billed curlew—quite rare.

Human habitation of Ossabaw goes back four thousand years to nomadic hunters who camped there seasonally. We know these people from the projectile points they created and lost or abandoned, and the shell middens they left as artifacts of occupation. Pottery came later, and there are plenty of sherds of it to be found washed up on Ossabaw's nine and one-half miles of beach. After the island was settled by Europeans at the end of the eighteenth century the occupation continued unbroken through plantations, hunting preserves, family retreats, and experimental communities to the present stewardship by the Georgia Department of Natural Resources.

Though the human and natural history of Ossabaw is quite long and well documented (the island has more than two hundred recorded archaeological sites), the more recent history that leads inextricably to the work contained in this book begins with the Torrey family, who bought the island in 1924. With the purchase of Ossabaw, Dr. Henry Norton Torrey and his wife, Nell Ford Torrey, began the process of saving the island from the land grab and development nightmare that has overtaken so many southeastern barrier islands in the past fifty years.

So far, the resort culture focus of twentieth-century sea island development has proven poor habitat for nurturing true art and artists. Each time a four-lane highway punches through the marshes and across the Intercoastal Waterway to open access to another barrier island, a little more of the artistic potential for that particular scrap of paradise drains into the ditches.

There are other sea islands that have escaped develop-

ment. Cumberland Island is larger, and Sapelo has the indigenous community of Hog Hammock. Part of what makes Ossabaw unique among Georgia's sea islands is its isolation; it's one of the few sea islands without a bridge or regular ferry service linking it to the mainland. It also has that fortunate family history. I've lived on Cumberland Island and have visited Sapelo and Ossabaw several times. Ossabaw has its own mystical, haunting qualities. Some say it's the way the tidal creeks push fingers deep into the island and trouble the air with the sounds of wading birds and the smell of pluff mud. Others suppose there are always ghosts associated with places of such long human habitation. I think the island haunts you when you leave it because it is almost impossible to experience such remoteness in the South. When you land on Ossabaw, ferried there by a private service or your own boat, you feel the way the first explorers must have felt—expectant and primed for discovery.

Ossabaw stayed in the Torrey family for eighty years. They used it in the early years for farming, timbering, and tree planting, and later mostly for hunting. Then in 1961, Eleanor Torrey West and her husband, Clifford West, established the Ossabaw Foundation, and activities on the island shifted quite strikingly toward the cultural. The foundation established the Ossabaw Island Project, a colony of thinkers and artists in the large rose-colored mansion on the island's north end, and from 1961 until it ceased in 1982 the colony supported twenty-five people at a time, eight months a year. Some of the leading writers and artists of the time, including writers Annie Dillard, Ralph Ellison, and Olive Ann Burns, architect Robert Venturi, and composer Aaron Copeland, took residence there. West has said that she spent half a million dollars annually on the project, and it did not go unnoticed or unappreciated. Alan Campbell, like many other artists, considers his time at West's island mansion one of the most productive periods of his career. Campbell, who was in residence there as a young artist in 1979 and again in 1981, says, "It was a transforming experience, both personally and professionally. It gave me the conviction to step into the great unknowable future as a self-employed artist."

In 1970 the Wests also established Genesis Project, a radical Ossabaw community of students—artists, scientists, and thinkers—who built their own habitations (one lived in an old boat pulled ashore, another in a tree house) and worked on projects ranging from books to wildlife studies. An experiment in cooperative living, Genesis Project was located at Middle Place, an old plantation site, and provided isolation and support for the study of the island's cultural and natural history and for the creation of art. Genesis Project appears in Ross McElwee's award-winning 1987 documentary, *Sherman's March,* the story of the

filmmaker's humorous attempt to trace Sherman's march through the South. The film turns into a meditation on McElwee's ailing love life. One extended section of the film takes McElwee to Ossabaw, where he visits a woman living in the tree house at Genesis Project. If a history of the counterculture in the South is ever written, its main narrative line will surely pass through Ossabaw and particularly through Genesis Project.

Because of the vision of Eleanor Torrey West (known to most as Sandy) and the access she has given artists to Ossabaw, we have more than sherds to show for the liminal space revealed between island and imagination. She knew that good artists always spend at least part of their lives living on the edge.

Campbell, Leigh, and Kilgo are not exceptions. Each has lived his own edge existence as artist, yet all three somehow remained close to home and to their heritage as southerners. When Alan Campbell arrived at the Ossabaw colony as a resident in 1979 he had abandoned a budding career as a college art professor. He says Ossabaw offered him "a place that believed in what I was doing." He remembers a conversation he had with Sandy West as a turning point in his life as an artist. She told him he would be "a fool to go to New York," something artists have always dreamed of and seen as a natural path for their careers, especially southern artists, who often see their home territories as provincial and limiting. Stay in the South, she advised, and "develop your own vision." So Campbell stayed, and his twenty-five-year career as an artist has led him back to Ossabaw many times.

Campbell's Ossabaw paintings are vivid and immediate. They swim deeply into the colors of the island world—the brilliant blues of sky and water and the myriad hues of green of the island's foliage. The painter has an eye for the particular patterns of this island world as well—the way salt creeks cross and intersect and how deadfall oaks form hexagons against the sky where ocean encroaches on Ossabaw's mature maritime forest.

This landscape has washed deeply into Campbell's soul. When asked about his extensive experience with Ossabaw, he talks of getting away from the human (he lives and maintains a studio in downtown Athens, Georgia) and "heading into the wild."

Jack Leigh grew up in Savannah and maintains a studio and gallery there. He is one of the South's best-known photographers. His image of a grave marker in a historic Savannah cemetery appeared on the cover of the bestseller *Midnight in the Garden of Good and Evil,* thereby attaining a sort of popular-culture immortality.

Leigh's relationship with Ossabaw, like that with Savannah, is deep and complex. *The Ogeechee,* his beautiful 1986 exploration of the Georgia river from headwaters to

Ossabaw Sound, brought him into contact with the island's sources as he followed the river from piedmont origins to confluence with the Atlantic Ocean. In that collection he used black and white photography and stories to create a human history of the watershed. Recently reprinted by the University of Georgia Press, *The Ogeechee* is an important southern environmental text. As a personal document the book announces Leigh's love for Ossabaw and his home territory outside Savannah. The photographs in this book lead him back to that potent source.

Leigh's black and white photographs in *Ossabaw* suggest a serene darkness to the island world. It is as if Leigh has stopped the constant convulsion of a sea island. There is somehow no sense of how unstable an island landscape made up mostly of sand and water can quickly become during a storm. There's a still point to every photo—a sturdy palmetto hanging perfectly over the morning marsh, a flight of hardy shorebirds caught in the stillness above spartina at full tide. Leigh is drawn primarily toward the primordial sea island, and its presence rises from his photographs. It's a world that predates the first hunter-gatherers and the first mediation of this landscape.

Athens writer James Kilgo, in the last years of his life, talked often of writing an entire book about Ossabaw, but the essay included here is all he finished of that project. At the time of his death in 2002 he knew the island intimately, and his "Place of the Black Drink Tree" returns the writer to the layering of human and natural history he explores so successfully in his earlier works *Deep Enough for Ivorybills, Inheritance of Horses,* and *Colors of Africa*.

Two "Ossabaw gatherings" in the late 1990s offered Kilgo a group of like-minded writers with ties to the region who were interested in discussing place, celebrating community, and defining the future of writing about the southern landscape. These weekend gatherings were blessed by Sandy West and brought together two dozen writers including Janisse Ray, Janet Lembke, Jeff Ripple, Susan Cerulean, Melissa Walker, Jan DeBlieu, and me. We talked long hours in the mansion's big hall, ate communal meals around the dining-room table, and toured the island's tidal creeks and beaches. In both gatherings, James Kilgo and Franklin Burroughs were our senior fellows in that fellowship of hope. When we left, the spirit of Ossabaw was something we each carried home.

If ecotones are areas of transition, what better time to introduce Ossabaw to the world through this powerful volume? Ossabaw is in transition. Its future is now determined by the state of Georgia, which acquired the island from the West family in 1978. Georgia's management plan will guide research, educational, and conservation activities on the island. We can only hope there is a space reserved for artists.

In 1995 Ossabaw was named one of America's most endangered places by the National Trust of Historic Places. Since that designation the island has become the first of Georgia's State Heritage Trust Preserves. The three artists whose work is presented in *Ossabaw* help us clear trails into the island's mysteries. They plot its coordinates as no GPS receiver could. Now, with the publication of this book, Ossabaw takes its place in the trust of the imagination, the fellowship of light, pigment, and prose.

JACK LEIGH

WALTZING TREES

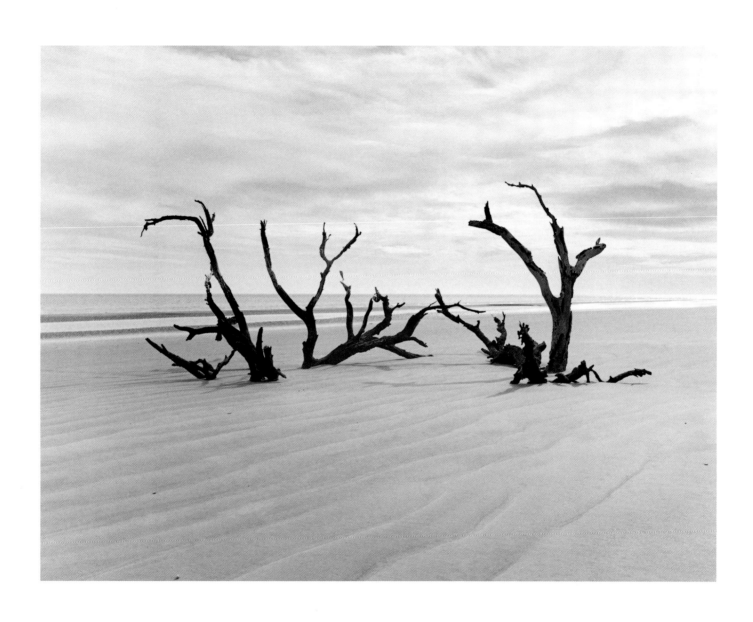

OSSABAW VISTA

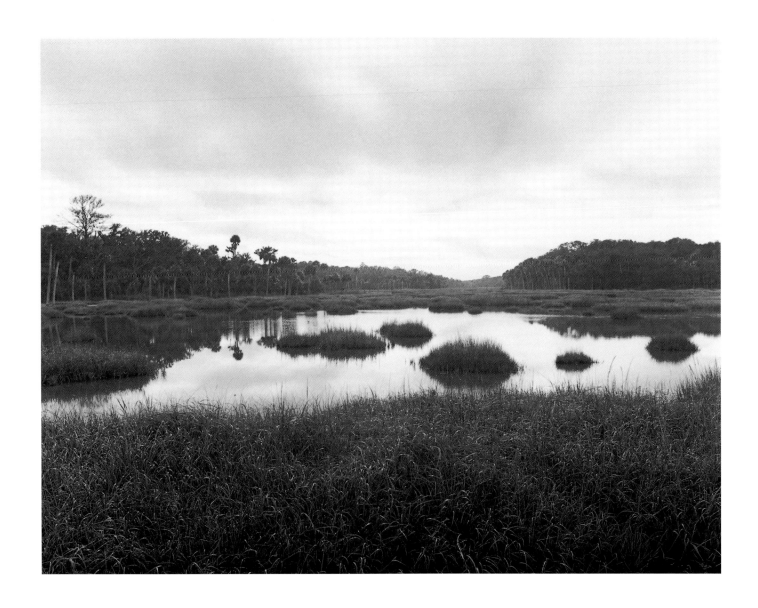

TWISTED TREE

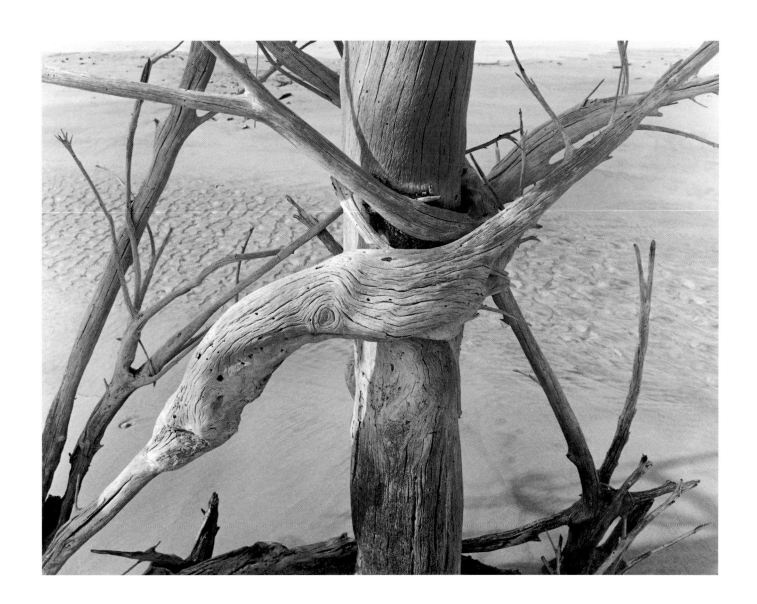

LONE TREE AT SUNSET

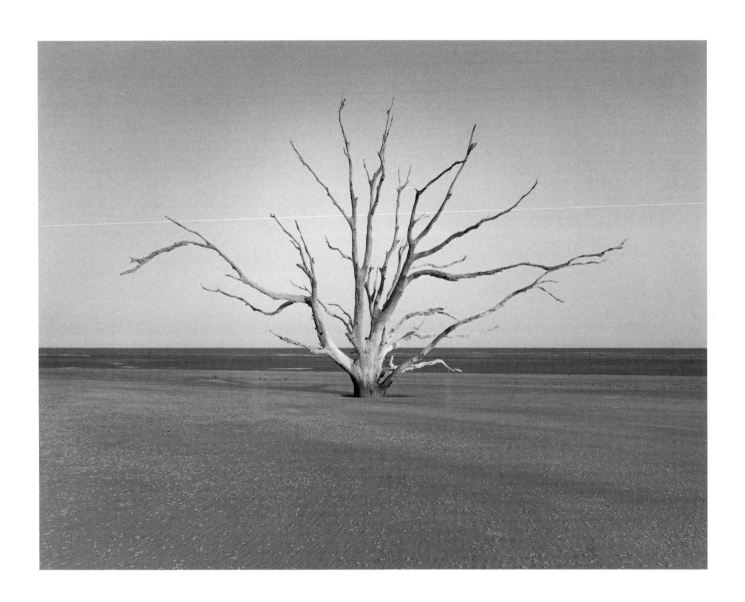

OSSABAW CREATURE

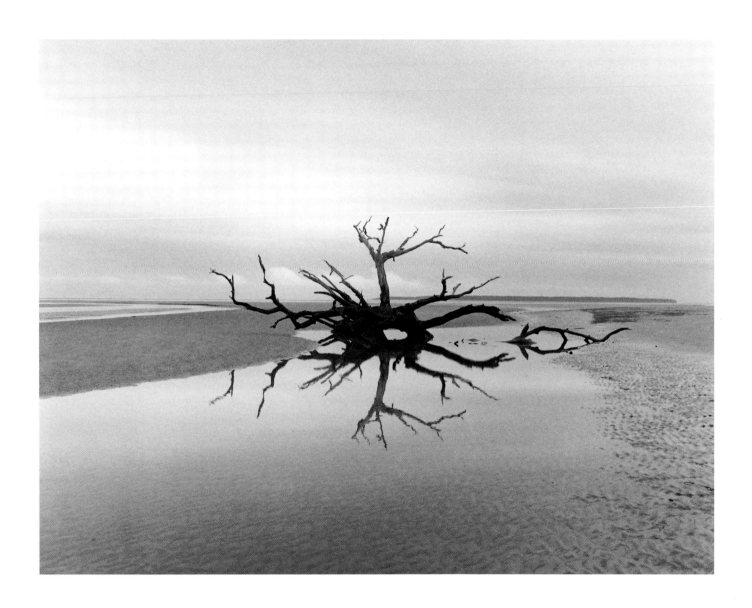

BIRDS AND TIDAL MARSH

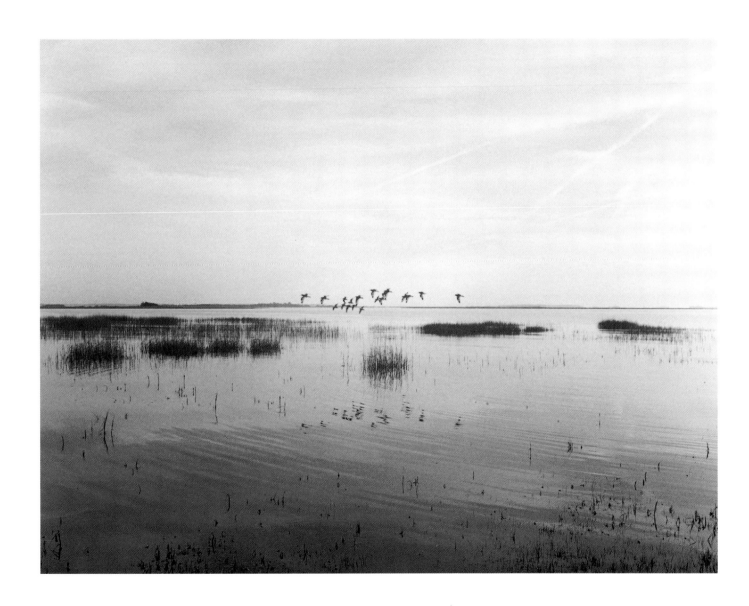

CREEK AT LOW TIDE

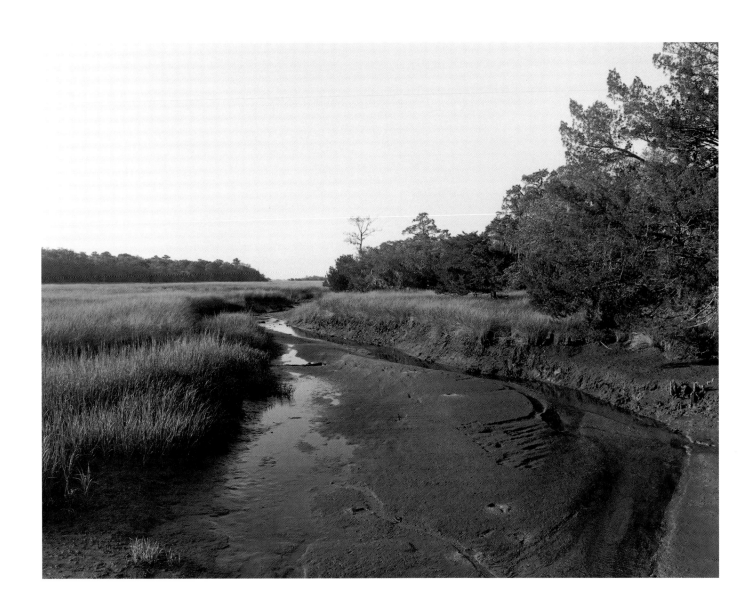

OAK LIMB REFLECTIONS

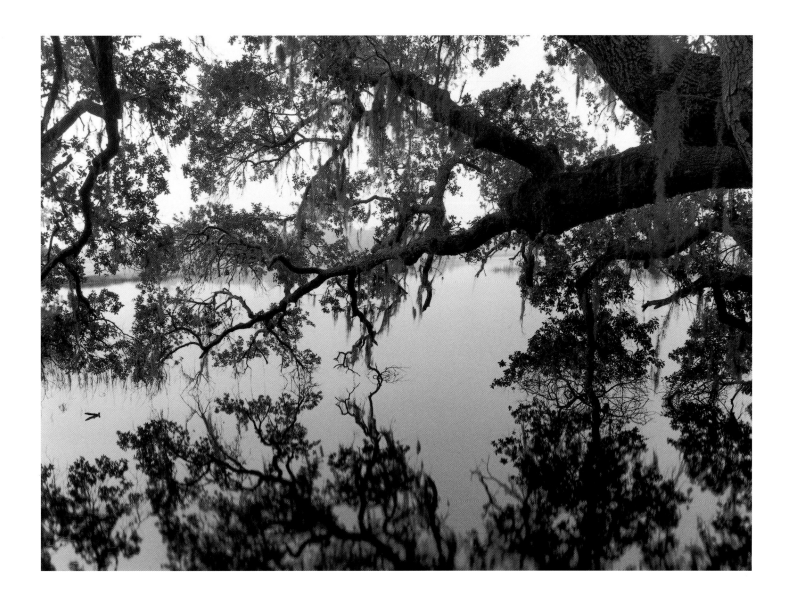

PALM TREE IN FOG

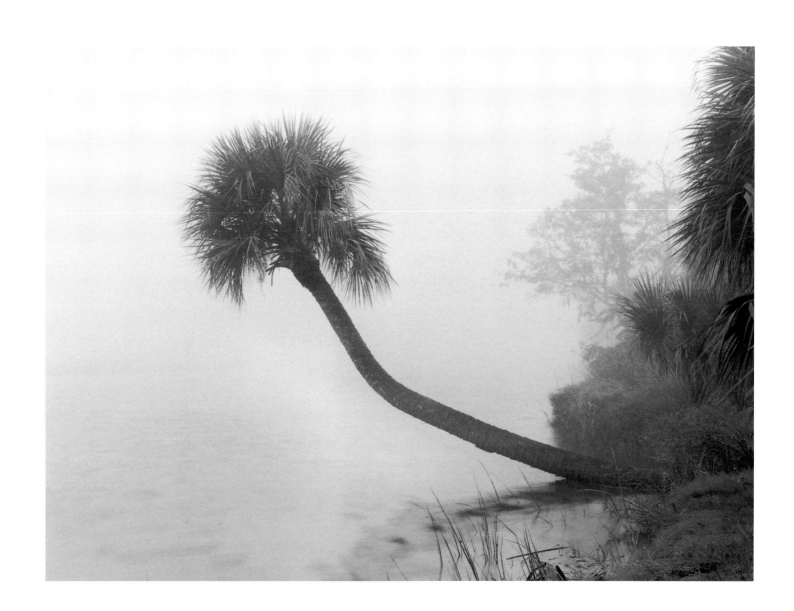

LIVE OAKS AND LIGHT BEAMS

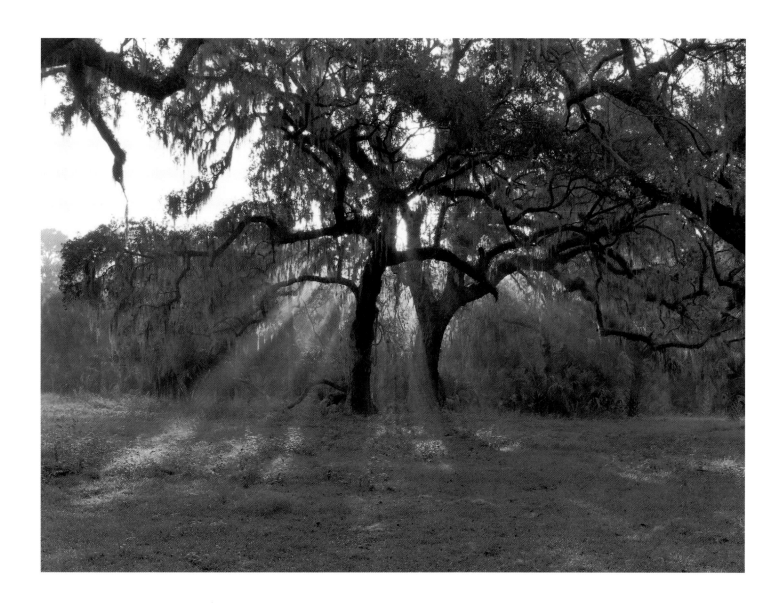

LEANING OAK IN FOG

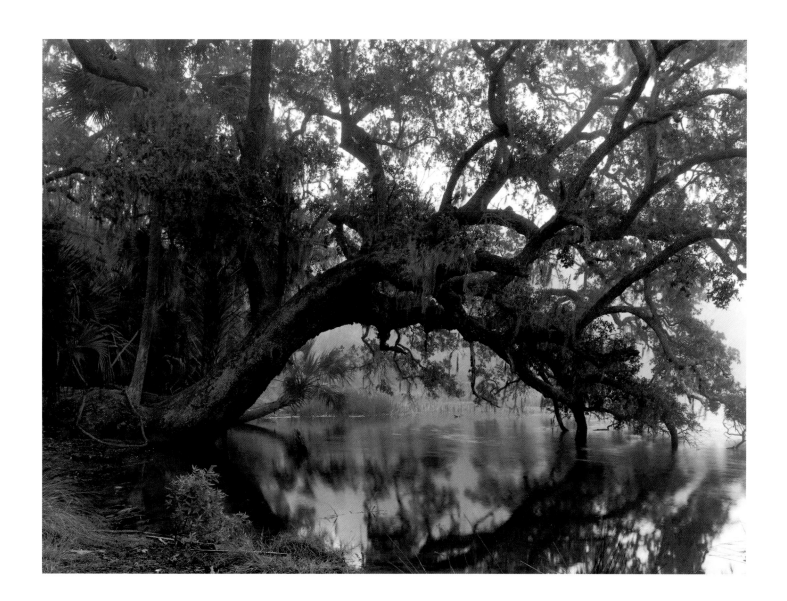

HANGING LIMBS

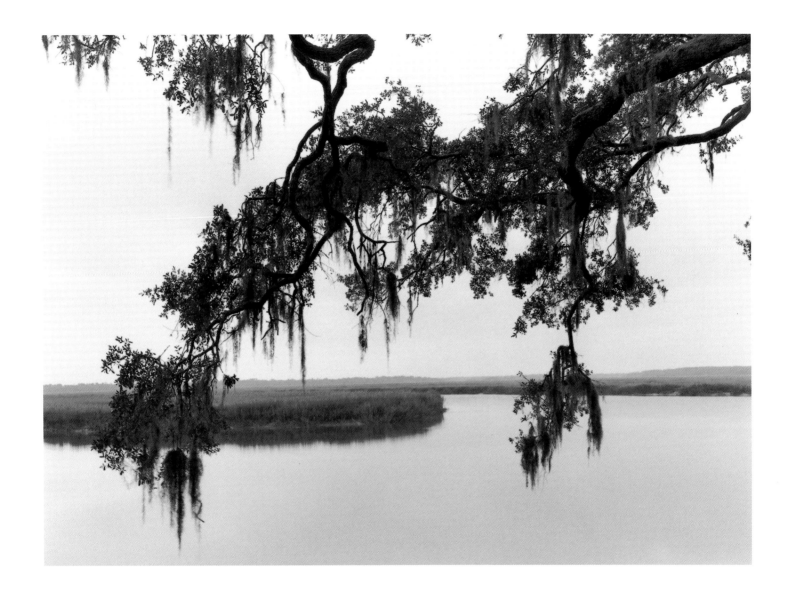

DUNES AND DRIFTWOOD

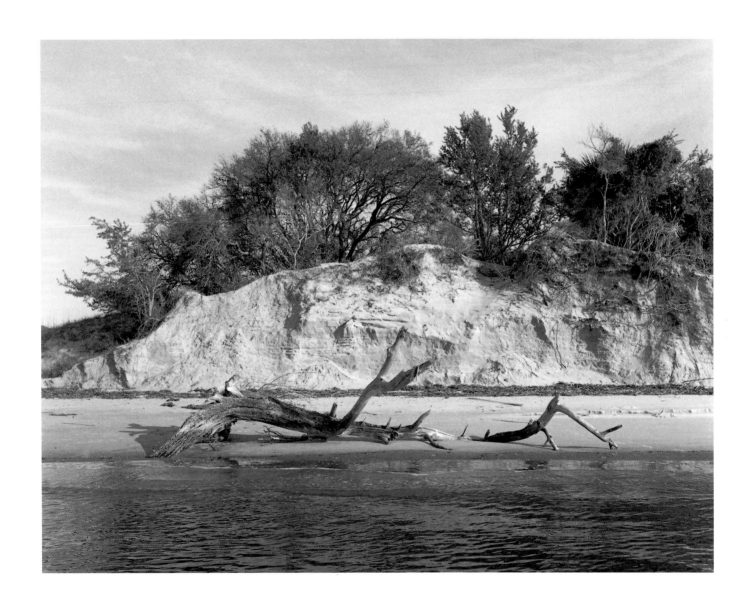

CEMETERY OF PALMS

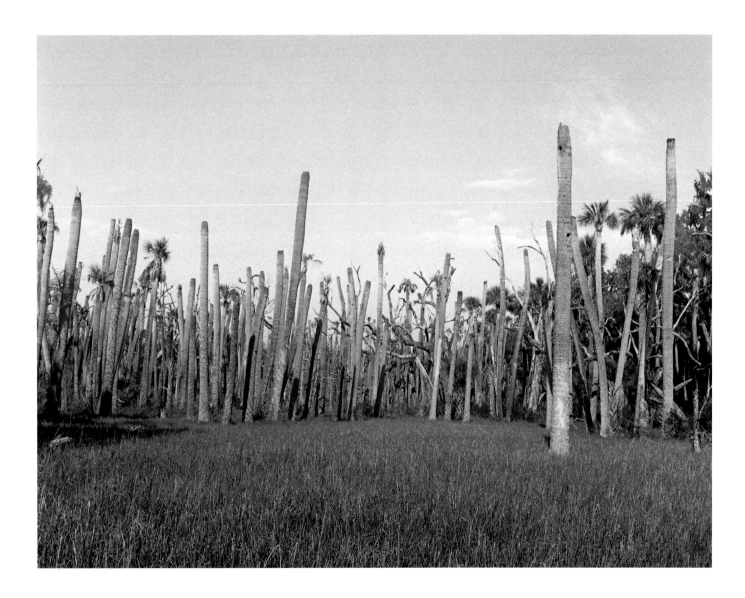

BLEACHED SERPENT

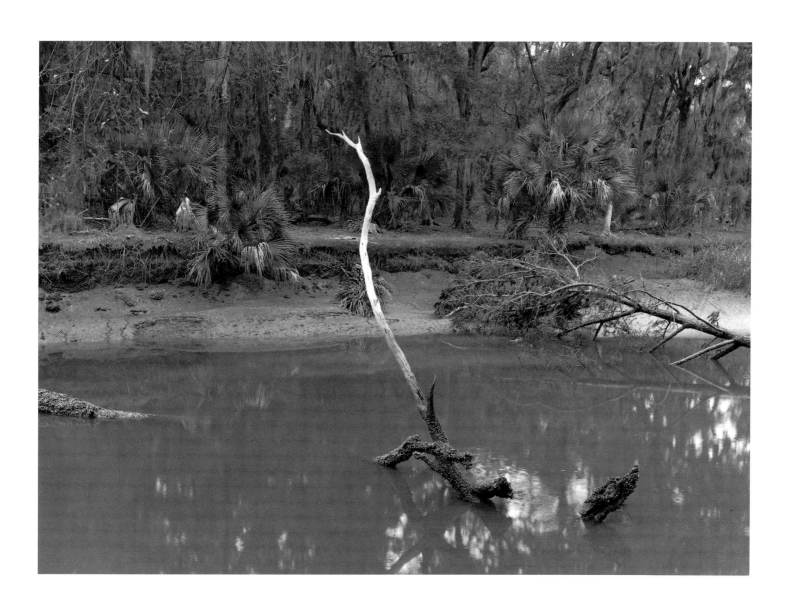

DEADFALLS IN CREEK

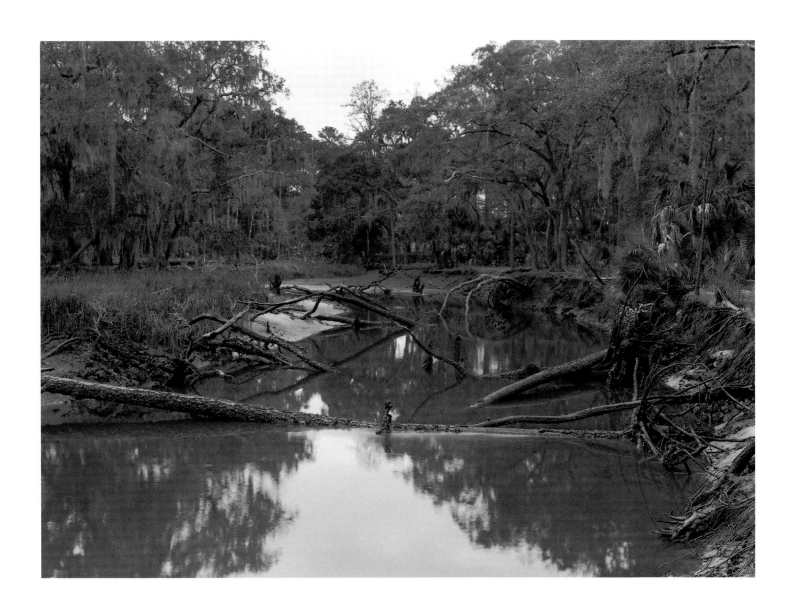

FALLEN TREES IN TIDE POOL

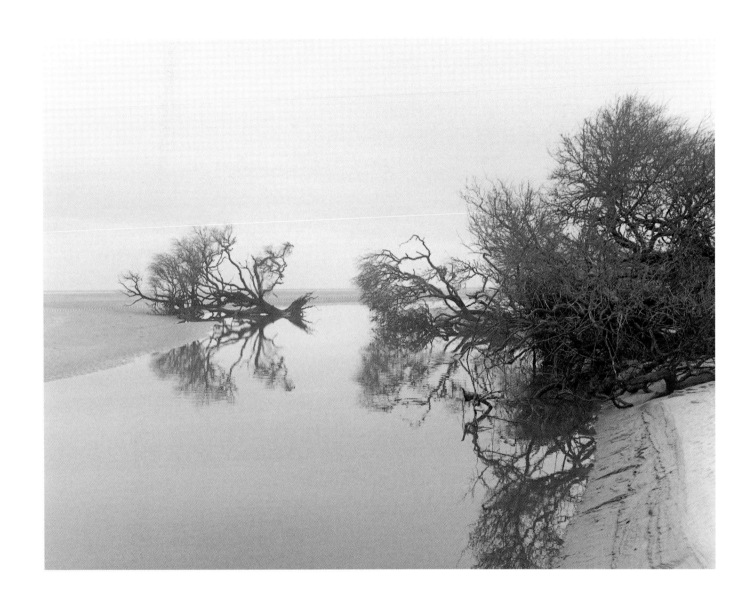

PALM FRONDS IN RIVER

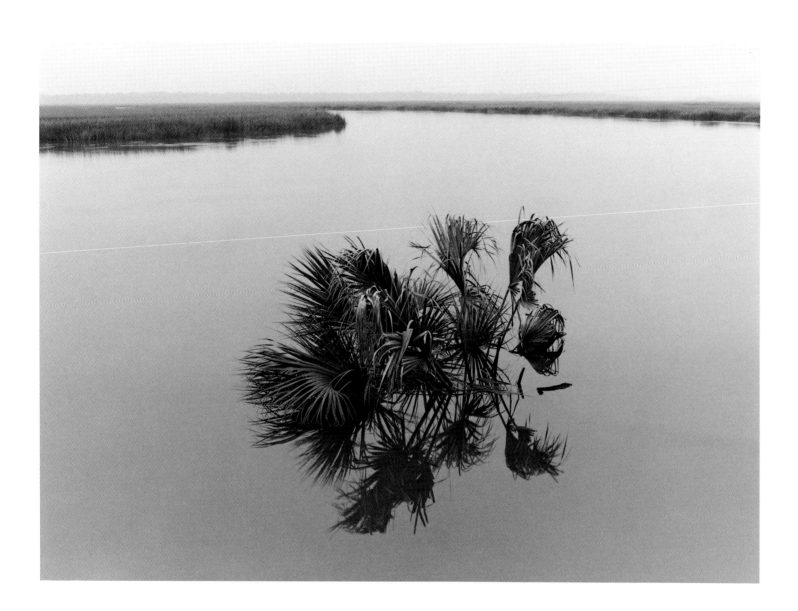

TENTACLES

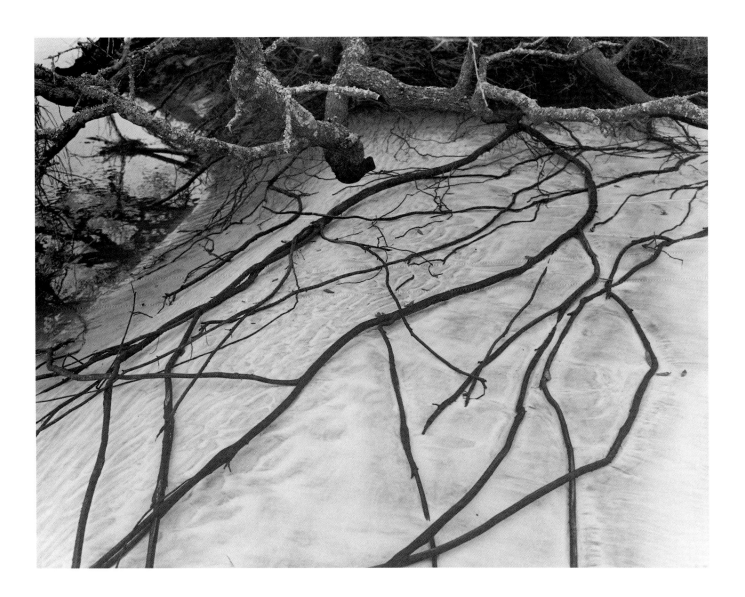

FOG VISTA

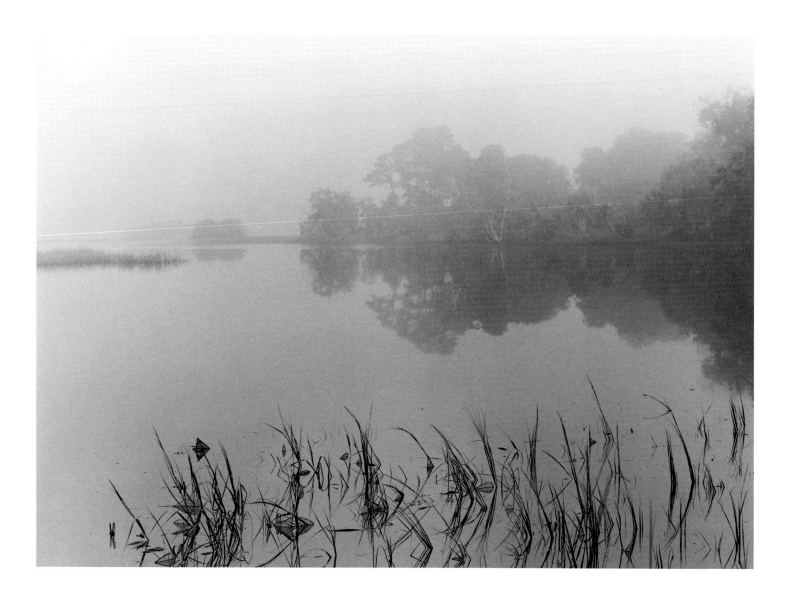

JAMES KILGO

PLACE OF THE BLACK DRINK TREE

Late in the afternoon of a late winter day I set out from the Ossabaw Main House to walk about the island. I have not left myself enough daylight to go very far, but even if the whole day lay before me I would soon run into the boundary that separates the private Eleanor Torrey West estate where I am staying from the rest of Ossabaw, which is owned by the state of Georgia. To venture legally into that domain I would need a letter of permission from the Department of Natural Resources, the current custodians of the island. I can understand the position of the DNR. They can't have just any self-styled nature lover running about unsupervised, tripping over alligators and bumping into wild boars. But still, having to apply for a letter makes me feel like a schoolboy asking permission to go to the bathroom.

I have walked a mile through live oak and longleaf and rustling palmetto, trespassing on the property of the state, of which I am a resident. The winter afternoon is growing dark and there is Cabbage Garden Creek, or a tributary thereof, a deep channel lying athwart my path. The bridge that once spanned the chasm has been lifted from its pilings by a spring tide and washed downstream and now lies wedged against a bend in the bank, intact but buckled. The DNR seems in no hurry to replace it, for the creek serves as a natural barrier to anyone headed in this direction from the West house. The pilings, encrusted with coon oysters, stand against the failing light, spooky sentinels forbidding access to the rest of Ossabaw.

I sit down on the bank and take out an apple. The stream below runs thin and tea-brown against white sand, hurrying out to the marsh and from there to Bradley River and the sound. Almost dead low tide. A good time to cross if it were not so late. Tomorrow I'll call the DNR, tell them I want to write a book about Ossabaw and need to walk the island to find out what to say. Sitting here on this side of Cabbage Garden Creek, I have no idea what that might be. Ossabaw is as close to natural as any of the big sea

islands—a rare instance of a relatively intact barrier island ecosystem on a large scale—but I'm not interested in writing a natural history. Such an account might be a good way of getting a grip on the island, but what I want is the island to get a grip on me. I want to experience it as a true place, a place that engages me body and soul and disturbs my dreams when I'm not here. But I'm afraid it's too late for that. I have not spent enough time here, or not enough time at the right time, when I was younger and the island might have imprinted my imagination.

From the right, foraging down the creek in my direction, come three black pigs—young animals, hardly more than shoats—their cloven hooves leaving cookie-cutter tracks in the firm sand. On they come, snuffling quietly among themselves, earnest in their constant search for something to eat. Their long snouts are gray with dried mud, and their sparse coats are matted with it. A light breeze is in my favor, but the slightest movement of my hand would send them grunting for cover. Directly beneath me now, they stop, suddenly confused. Their soft grunts sound inquisitive. Did anybody smell a man? Suddenly they bolt, scampering up the opposite bank and into the rattling palmettoes.

The island is overrun by feral swine. You see them everywhere, for the most part small and black like these, but some are red and some belted, betraying barnyard blood.

Where they came from is a matter of controversy with serious practical consequences. I. Lehr Brisbin, a population geneticist who has studied these pigs for many years, has told me that swine first came to Ossabaw in the seventeenth and eighteenth centuries, brought from Europe as a food supply by Spanish explorers and missionaries. That original breed was a small, slab-sided, long-snouted, bluish gray animal called Mangalitza, the typical domestic pig of southern Europe at that time. Brisbin believes that a remnant population survived on the sea islands until the eighteenth century, when the islands became cotton plantations and planters introduced porcine stock of their own to help feed their slaves. A mongrelized breed survived the demise of plantation culture and established itself as a part of the island fauna. As a result of their long isolation, Brisbin says, Ossabaw pigs have developed a unique biochemistry. They have learned, for example, to tolerate a high degree of salt in their food and drinking water. Because long-term feral populations of *Sus scrofa* rarely occur anywhere, he wants to see at least some of the Ossabaw pigs protected. The DNR, however, is not buying his argument. They point to red and belted pigs as evidence of recent introductions of recognizable domestic breeds that have corrupted whatever original gene pool might have existed, leaving the island overpopulated with ordinary feral pigs that are doing serious damage to the

environment, uprooting native plants and raiding turtle nests.

Whichever side is right—and this is a case where both may be, in complicated ways—the pigs prompt me to wonder what it felt like to be on Ossabaw before they were here—pre-pig Ossabaw when bears, wolves, and panthers roamed these woods, and the people who lived here had no notion of property lines. That's the Ossabaw I'm looking for, not in a romantic spirit of primitivism but with a fairly certain sense that until four hundred years ago the island lived and breathed as the earth was created to live and breathe. Though both Mrs. West and more recently the DNR have allowed it to return to a semblance of its natural condition, what I seek is accessible only to the imagination, and mine keeps stumbling over pig sign. Their tracks remind me of Gerard Manley Hopkins's poem "God's Grandeur," part of which insists on intruding:

> *Generations have trod, have trod, have trod;*
> *And all is seared with trade; bleared, smeared with toil;*
> *And wears man's smudge and shares man's smell: the soil*
> *Is bare now, nor can foot feel, being shod.*

That's enough to make me want to take off my shoes, which I think I'm about to do anyway. Across the creek stands a yaupon holly, the tree, they say, for which the island was named. Anthropologists have long supposed that *Ossabaw* derives from a Muskhogean-Hitchiti word said to have meant, in that now lost language, *place of the black drink tree,* or *where yaupon holly grows.* The plant—*Ilex vomitoria*—produces a dark tea strong in caffeine that Indians throughout the coastal plain drank as a ritual, consuming it to purify themselves for council meetings or war. A drawing of the coastal Indians by sixteenth-century artist Jacques le Moyne shows that they drank it hot, using conch shells to dip it from frothing cauldrons, and consumed it until they began to sweat profusely and finally to vomit. A draft of black drink might be just what I need. The virtue of the tree, maybe even an essence of the true Ossabaw, should remain inherent in the leaves. All I have to do is get my feet wet and break off a branch. Seems worth a try.

The procedure is unassisted and experimental. In the kitchen of the Main House I strip the small dark green leaves from the branch, throw in a few twigs, and parch them brown in a cookie pan in the oven. I don't know what prayers the Indians might have offered or at what points, but I proceed with reverence and common sense, crumbling the parched leaves between my palms until they are reduced to a handful of aromatic fragments. Then I measure a certain amount into a mug and pour in boiling water. The black drink has a serious taste, somewhere between strong tea and coffee, a wild oaky taste with a bitter

edge. I don't drink enough to make me vomit, but after two mugs I am prepared to go out in search of whatever it is I'm looking for.

The island is shaped like an arrowhead, pointed south. Running down the center, like a spine down the middle of a back, is a low ridge of solid ground, almost imperceptible to walking feet. For obviously good reasons, the earliest white inhabitants of the island used the ridge as the bed of their main north–south road, though they may well have been following a path beaten out by bare feet over many centuries, for terrain has a way of directing the steps of hunters as well as planters. As I head south, I keep off the road, choosing to wander through the woods instead, along enchanted green aisles that lead me aimlessly among great snaking boughs of live oak and groves of old longleaf. Once, I drift far enough to the east to glimpse the marshes of the Bradley River, for the higher, wooded ground amounts to only 40 percent of the island. If I were an Indian, this is where I would have lived, in this cathedral shade, brushed by horsetails of Spanish moss, venturing out to the edge of the hot salt marsh only to make my living, gathering oysters, crabs, shrimp, and periwinkle.

In fact that's what they did, at least the ones who inhabited Ossabaw for the six or seven hundred years prior to European contact in the sixteenth century. Proof of their occupation lies about me in these woods—little heaps of oyster shell, small and irregular in circumference and hardly elevated above ground level, so inconsequential that the untrained eye would miss them altogether, as mine did until the archaeologist Chester DePratter brought me here last year. DePratter had conducted excavations on Ossabaw back in 1974. Among other projects on the island, he was trying to locate burial mounds first discovered in 1897 by an amateur archaeologist named Clarence B. Moore, who was the first to undertake a systematic archaeological survey of the southeastern coast. On Ossabaw Moore found two concentrations of mounds, one near Middle Place in the center of the island, and the other on a bluff above Cabbage Garden Creek not far from where I am right now.

Like most boys who grow up in the rural South, I would sometimes find an arrowhead, and the artifact would evoke by the power of its medicine a shadow world of Indians, not confined to the past but living simultaneously with me though unseen. I knew nothing about them—not their tribal name or their language or even how long it had been since they walked the earth—but I knew they were there, had been and somehow still were—a mysterious people who understood the world as it was made in ways and at levels that our time never could.

Moore devoted himself almost exclusively to a search for burial mounds, and he found what he was looking for—in mound after mound scores of skeletal remains, probably the majority of them primary interments, with the corpse in a flexed position lying on its side; others were "bundled," or dismembered and folded into urns, and still others calcined as a result of cremation. What he found precious little of were grave goods—artifacts interred to honor the deceased or to equip them for life in the next world. In fact, little about the burials suggests that the Indians believed in life after death.

Because of Moore's painstakingly accurate drawings of pottery sherds and pipe bowls, archaeologists have been able to establish for many of the mounds a cultural and temporal context. The people who buried their dead in mounds on the barrier islands lived there during the Woodland and Mississippian Periods, from about 500 BC right up to the time of European contact in the sixteenth century. Bones of animals and remains of shellfish tell us that they were hunter-gatherers, and there is some archaeological evidence to indicate that they engaged to a limited degree in agriculture. Moore discovered a few artifacts—copper gorgets and pipe bowl effigies—that indicate ceremonial activity in the lives of these people, but the ethnologist has to turn to other sources to learn of their social organization and belief system.

Among the most useful of these sources are eyewitness accounts of the Timucuan Indians written in the sixteenth century by the French explorer René de Laudonnière and Jacques le Moyne, the artist who accompanied the expedition. Le Moyne made sketches and drawings of the Timucuans but died before he could get them published. His widow sold the collection to a Flemish engraver named Theodore de Bry, who produced forty-two illustrations allegedly copied from le Moyne's work. They have been recognized ever since as the earliest graphic documentation of coastal Indian life, the next best thing to photographs. Though the Timucuans lived south of the Guale, the tribe that inhabited the northern Georgia coast and islands, ethnologists believe that they shared the same cultural mores.

Still, one has to be careful here. Because le Moyne's originals have not survived, it's often hard to tell which details are authentic le Moyne representations and which are products of de Bry's rather generic imagination, hence of little ethnological value. At least one scholar has identified only thirteen of the forty-two illustrations as authentic le Moyne. Finally, de Bry transformed le Moyne's Indians into idealized Greco-Roman figures, apparently to please the eye of customers. Even so, when studied in conjunction with le Moyne's notes and Laudonnière's accounts, the images have the power to resurrect the dry

bones that lie all about me in these Ossabaw woods and set them to walking and talking again.

When Hernando de Soto hacked his way through the Southeast in 1540, he encountered a highly developed civilization, a socially and politically complex people living in large towns built around plazas and temple mounds. That civilization—the Southeastern Ceremonial Complex—constituted no single tribe or language but, stretching from the valley of the Ohio River to the Florida peninsula and from the Mississippi River to the great ocean in the east, comprised many different groups and tongues. The people living along the lower southeastern coast were small marginal tribes, separated from the major inland chiefdoms by geography and language and shaped by their particular coastal environment, but they nevertheless observed in their own ways the cultural mores of the prevailing ethos, one of which, for example, was the black drink ritual.

De Bry's idealized renderings tell us little about the appearance of the natives, but le Moyne and Laudonnière both describe the coastal Indians as tall—noticeably taller than themselves—olive-skinned, and athletic. Men wore their long black hair tied up and bound in a caplike dome and decorated with circlets of feathers or tails of animals such as raccoons. They painted their faces blue and tattooed their arms and legs and chests in intricate patterns and wore dyed fish bladders in their pierced earlobes, shell gorgets around their necks, and bracelets of various devices on their ankles and wrists. Except for a breechclout, men went naked, while women wore aprons or girdles of Spanish moss.

Along the rivers that emptied into the sea, the Indians lived in towns often surrounded by palisades, in round houses facing a plaza. The chief and his subordinates met in a council house where they consumed black drink and debated questions concerning tribal policy. They lived by hunting deer and small game, fishing with nets and weirs, gathering shellfish, and planting fields of maize, which they harvested and stored in communal barns. They were also accomplished craftsmen, impressing the colonists with their skills in fashioning large, beautifully decorated clay vessels, tanning deer skins to a chamoislike softness and decorating them with drawings of animals rendered in naturalistic detail, constructing dugout canoes, and of course manufacturing tools of agriculture and weapons of war, for which they trained by playing games of speed, strength, and agility. According to the French, who were constantly starving in a land of natural bounty, the Indians lived well and comfortably.

What strikes me most in the accounts of le Moyne and Laudonnière is the demeanor and comportment of the In-

dians. These were not timid, fearful, awestruck savages but intelligent, self-assured members of a proud society. Though they were appalled by the colonists' loud firearms, they seemed not to consider themselves in any way inferior to the white strangers who covered their smooth skin with metal and fabric. How could they? If by European standards the colonists were technologically superior, their guns and clothing did not help them adapt to the environment. And not because the environment was harsh or threatening as it might have been in the desert West or the cold North. It was because the Europeans had for centuries been evolving into a cultural artificiality that removed them further and further from the natural world. The inevitable result was loss of knowledge of such things as the medicinal properties of herbs, the food value of certain wild plants, and the vagaries of weather. But worse than that, their lifestyles had generated an attitude that was all but impenetrable even to the possibility of adapting their ways to an unfamiliar natural environment. They must have been amazed, for example, by the Indians' mastery of terrain—not just familiarity with home territory that anyone might acquire, but their ability to negotiate without maps the maze of tidal streams and creeks that interlaced the marshy coastland.

Every time I have crossed by boat from the mainland to one of the barrier islands, I have been confused by 360 degrees of featureless green landscape, blurred edges, and muted tones, and I have wondered how, if the captain of the boat became disabled, I would find my way back to solid ground. There must be thousands of people—shrimpers, fishermen, even pleasure boaters—who navigate the coastal waterways every day, reading wind and tide, but the Indians did it in canoes, without charts, radio, radar, or sonar.

In his book *Another Country,* Chris Camuto suggests that the early Cherokee found their way through the rumpled landscape of the southern mountains by the use of myth and song, which imprinted on their minds story lines that served as maps. The same techniques may have worked for the inhabitants of this country of flat horizons. Though we may assume that the Guale had their myths and sacred formulas, their language, which might have provided access to their belief system—as Cherokee did for James Mooney—is utterly extinct. Scholars are no longer even sure that it was a Muskhogean tongue, as has long been supposed. Yet the de Bry engravings encourage us to assume that the coastal peoples, like the proto-Cherokee and other tribes that lived within the embrace of the Southeastern Ceremonial Complex, inhabited a world in which, as Camuto says, "the sacred was real and culture and nature were two aspects of a single practice."

Two of the de Bry engravings depict religious activity among the Timucuans. In one, Outina, the cacique or chief, kneels at the side of his shaman, whose body is contorted in the throes of a prophetic experience. "When it was over," le Moyne writes, "he returned to his normal condition but seemed exhausted and terrified. He left the circle and told the chief the position and strength of the enemy." The other portrays an annual religious ceremony. At the end of February, Outina's subjects stuffed with choice plants the skin of a buck, complete with head and antlers, which they then placed at the top of a great pole or tree trunk so that it faced the rising sun. Led by Outina and his shaman, the people danced and chanted prayers for a rich harvest in the coming year.

These two illustrations tell us little about the nature of the Timucuan belief system, only that they had one, as in all probability did the Guale. For them as for the Cherokee, the world was informed by spirit—a power that resided in all animals, trees, and plants, the sky, and the water. Spirit was neither good nor evil, but it demanded acknowledgment and respect. It breathed life into the world. The creation sang of it and by it, and the myths and stories of the people caught the song. As they sang the songs, generation after generation, their sense of themselves—their collective identity—fused with the place, making it impossible for them to conceive of one apart from the other.

Here comes an armadillo, a hard-shell football, with a small face that looks like it should belong to a different animal, trundling through the leaves. Because of weak eyesight, it comes straight to where I'm sitting, stops at my feet, stands on its hind legs, and sniffs the air. Light shines through its paper-thin pink ears. Something's not quite as it should be, the creature decides, and turns and shuffles away, indifferent to the possibility of danger.

Armadillos are recent invaders of the sea islands, and they seem to be thriving, perhaps because of the absence of any animal with claws capable of hooking one under the edge of its shell and flipping it onto its back. Except for alligators (*Alligator mississippiensis*), Ossabaw is empty of large predators, but it wasn't always. Until the coming of Europeans the island was home to red wolves (*Canis rufus*), black bears (*Ursus americanus*), and occasionally even panthers (*Felis concolor*)—animals capable of defining an environment. They would not have presented a dire threat to the Indians, but they constituted a powerful presence, strong enough to have directed the energy flow of the ecosystem. The wet-dog smell of bear mixed with the musk of cat would have charged the breeze with odor, and

the howling of the wolves would have set the air aquiver. People who lived among such creatures must have been different in some real metaphysical sense from those who don't, and I suspect the extirpation of the predators would have been a hard thing for aboriginal man to survive. To the Indians who watched the last of the predators go, the islands must have seemed to have sunk into senile dementia.

Bobcats would be better than nothing. I want to believe that at least a few are still around, but DNR biologists say no. They aren't even sure they were ever here, but the small cats were certainly indigenous to some of the islands, and restoration efforts have been successfully undertaken on Cumberland. So why not here on Ossabaw? They might have an impact on the pig population. I know they would change the atmosphere.

The center of the local chiefdom was not Ossabaw but the next island south, called Guale by the inhabitants but renamed Santa Catalina by the Spaniards who attempted to establish a mission there in the 1570s. The Spaniards' initial efforts succeeded only in antagonizing the Indians—the priests told the caciques that they could not go to heaven unless they got rid of all but one of their wives—and several Jesuits died in the uprisings that followed. Not until 1605, when Franciscans built a mission, did the Spanish begin converting large numbers of Indians—286 in 1606—but in a few short decades there were no Indians left to evangelize. European diseases against which the Indians had no immunity devastated the population, but long before measles, mumps, and whooping cough took their toll, the indigenous culture had succumbed to the authority of the Spanish church and state, which on the coast of the new world were virtually the same.

Historians knew for a long time that Spanish Franciscans established a mission on what is now St. Catherines Island, but it was not until the 1970s that a team of archaeologists, under the direction of David Hurst Thomas of the American Museum of Natural History, found it. Located on the back side of the island, near the marsh, it was built alongside the Guale town but designed according to a template prescribed by the Royal Ordinances of Philip II—"a direct attempt," Thomas says, "to transplant a 'civilized' way of life upon America's wilderness." Buildings, he said, "were laid out along a rigid pattern. . . . A rectangular plaza defined the center of the complex, [and] [h]ousing in the pueblo consisted of rectangular buildings, perhaps separated by 'streets.'"

One could hardly represent more clearly the dominant

fact of the European presence in the New World: a rigid form, paradigm of the Western sense of order and control, imposed on a culture that had always lived in harmony with the landscape. No wonder the Guale succumbed to foreign pathogens. When the British at last drove Spain from the Georgia coast in 1680, a handful of surviving Indians—too young to remember what life had been like for their grandfathers—followed the Franciscans to St. Augustine and eventually became extinct. The islands, until recently domain of a thriving culture, were inherited by the pigs the Spanish left behind. Their progeny still run freely across the burial mounds of the Guale.

I find my way to the main road and turn right, north toward the West house. I move through an alley of ancient live oaks, planted in the eighteenth century by the first white owners of Ossabaw. Before long I pass a mile post, a slate marker a foot or so tall, standing just off the road, incised with the Roman numeral II, which means that I have two miles to go before I reach the north shore where the measurement started, and then another mile from there to the West house. The markers were put in place by eighteenth-century planter John Morel, to whom clocks and measuring chains must have been important. His will divided the island into three roughly equal parts, one for each of his three sons. Straight ahead, at the end of the avenue, I begin to make out the façade of the Club House, a prefabricated structure shipped down from Philadelphia, it is said, by the mercantile magnate John Wannamaker, who owned Ossabaw from 1895 to 1906, and erected on the site of Morel's North End plantation, which had burned. I pass a DNR equipment shed on one side of the lane and a machine shop on the other, and then, as I emerge from the tunnel of live oaks, a fenced field opens on the left. Facing the field stands a row of three pre–Civil War tabby cabins, all that's left of the streets of slave quarters. These fragments of the history of the American presence on Ossabaw constitute a visible expression of the grid that white people have been imposing on the island for four hundred years.

The greatest difference between the Indians' experience of the island as place and the view that has prevailed ever since came about at the instant Ossabaw was placed on the auction block and sold for money. At the center of that momentous event stood the woman Mary Musgrove, who claimed royal Creek blood. Mary, who was a daughter of a Creek woman and an English trader, had served as interpreter for James Oglethorpe when he established the Georgia colony in 1733. By treaty with the Creeks, the colony acquired ownership of the Georgia tidewater from the Savannah River to the Altamaha River, except for the islands of Ossabaw, St. Catherines, and Sapelo, which

were set aside as Creek hunting grounds. In 1747 the emperor of the Creek Nation deeded the islands to Mary and her husband, an Anglican clergyman named Thomas Bosomworth, but that transaction was not recognized by the Crown, and the Bosomworths sued, Mary claiming that the Crown owed her money for her services to Oglethorpe. The dispute was finally settled when the court ordered that Ossabaw and Sapelo be sold at auction, the proceeds to go to the plaintiffs, who used the money to purchase St. Catherines.

So Ossabaw entered the marketplace, first as a commodity and then as an investment. Over the next one hundred years it was plowed and planted, ditched and dyked, surveyed, divided and subdivided, bequeathed, bought and sold. The plows of the planters, wielded by African slaves, tore open the surfaces of Guale burial mounds, the oyster-shell fill was hauled away as ballast for roads, and the grid of nineteenth-century slave-based agriculture eventually concealed the world of the Indians.

The various efforts of white people to impose order on the island have not lasted long—not according to the island's sense of time—because the grid, though dense, is as thin as a spider web, and most of its lines, especially the scars of the plantation era, have already disintegrated back into the ground. Nature down here on these steamy barrier islands is quick to reclaim its territory. Ironically, one of its most effective agents is a thriving population of swine, which have no respect for roads or fences. Left to themselves, as these have been for long periods, they can wreak havoc not only on the natural environment but on carefully surveyed property lines as well.

It's hard to resist the temptation to see the pigs as little metaphors of our own feral tendencies—say greed, for example—natural wild animals that despite millennia of domestication remain always within one generation of breaking through fences and running wild again. Or, better, as a pathogen that Europeans cultivated and imported into the garden of the New World, where they lost control of it.

The DNR couldn't care less about metaphors. They have real animals to deal with, and the management plan calls for the complete eradication of the pigs. Good luck. The DNR may get most of them, but they are going to have to get them all if the program is to be successful, and finding those last three or four on an island of this size will take a while. Pigs are as smart as they are prolific. Start shooting at them and see how long it takes them to disappear. Which renders my ambivalent position moot.

One day a couple of years ago, as I was walking the lane behind the Main House, a movement in the palmettoes off to the left caught my eye. The late afternoon sun was shafting through the canopy, and amid the light and shadow, partly concealed by foliage, stood a pig of a silver

color. I had never seen such a thing. It was of moderate size—a grown animal—and it almost gleamed. I stepped forward for a closer look, but just as an image reflected on water is broken into a thousand flakes by a sudden gust, so the silver pig disintegrated in a shift of light and shadow that rustled the undergrowth. After the pig was gone, I realized that the illusion of silver must have been simply a trick of sunlight, but then it occurred to me that the trick would require a pig of unusual color, say a steel-dust blue, which is rare among swine—so rare in fact that I have known it to describe only the ancient Mangalitzas. Maybe that's what I saw—an original pig plated silver by the sun.

If so, it means that pigs have flourished here for four hundred years, and they have not destroyed the island yet. Like Brisbin, I'm in favor of preserving at least a remnant. On the other hand, most of the pigs that cross my path appear to carry genes of recent domestic introductions, and their abundance smudges the natural beauty of Ossabaw.

Even the complete extirpation of the swine population, though, will not restore the soul of this place. That would take wolves and panthers and Carolina parakeets, whose brilliant green feathers adorned the heads of Guale warriors.

ALAN CAMPBELL

ESTUARIES

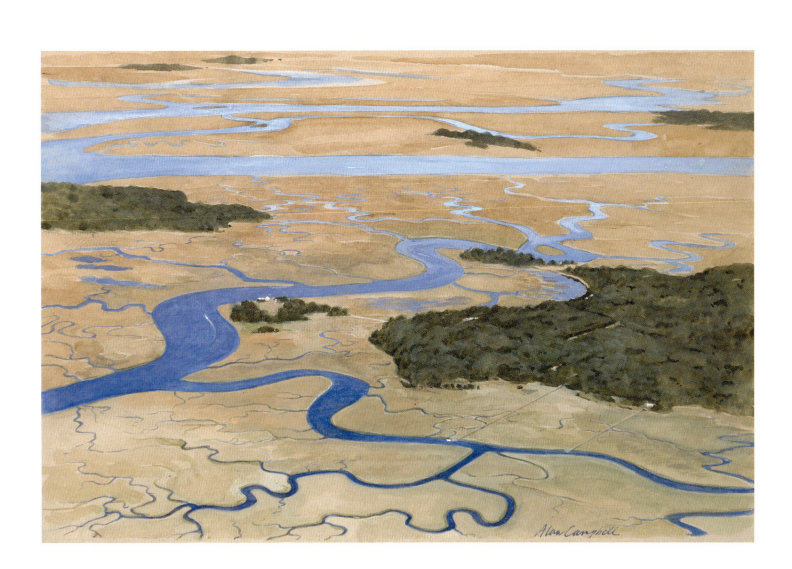

BONE TREES

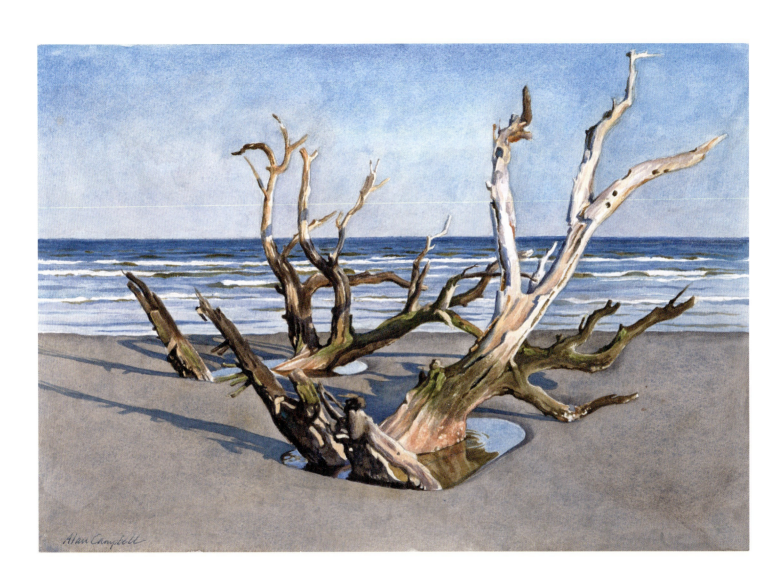

BRADLEY BEACH DUNES

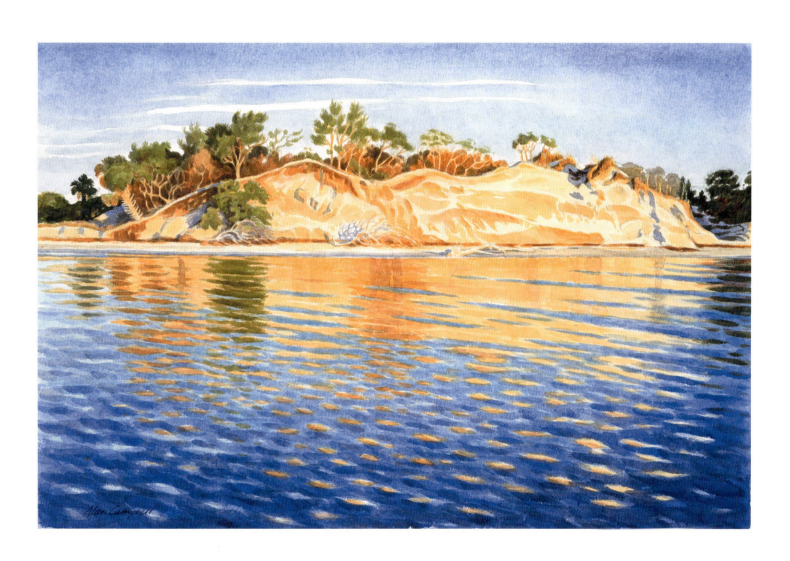

BLACK WATER POND

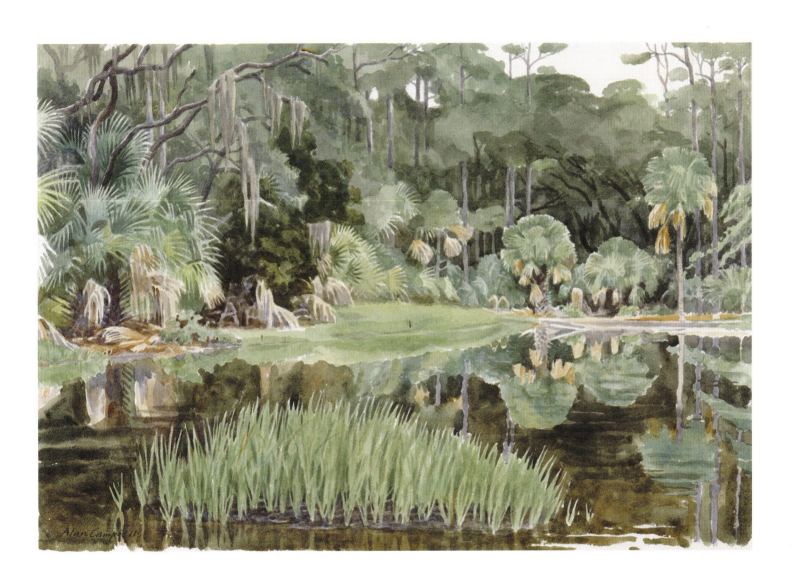

OSSABAW MORNING

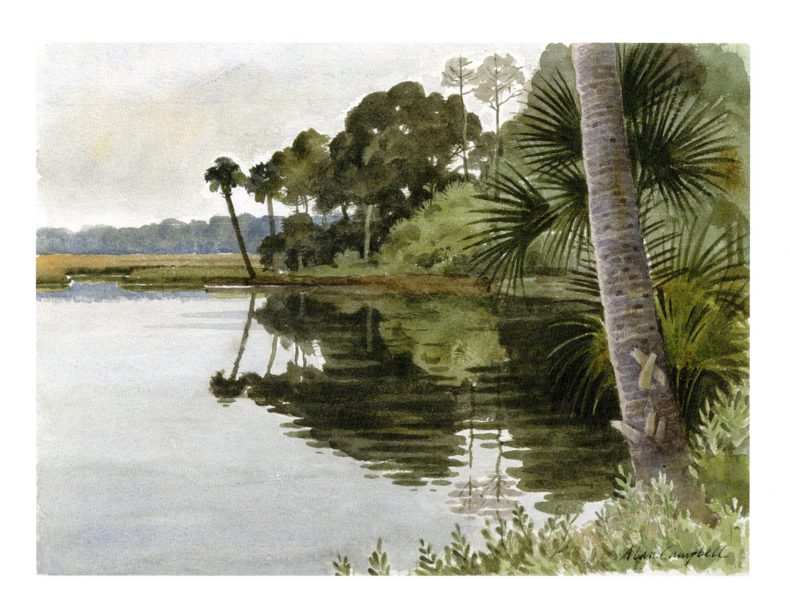

DAYBREAK ON OSSABAW

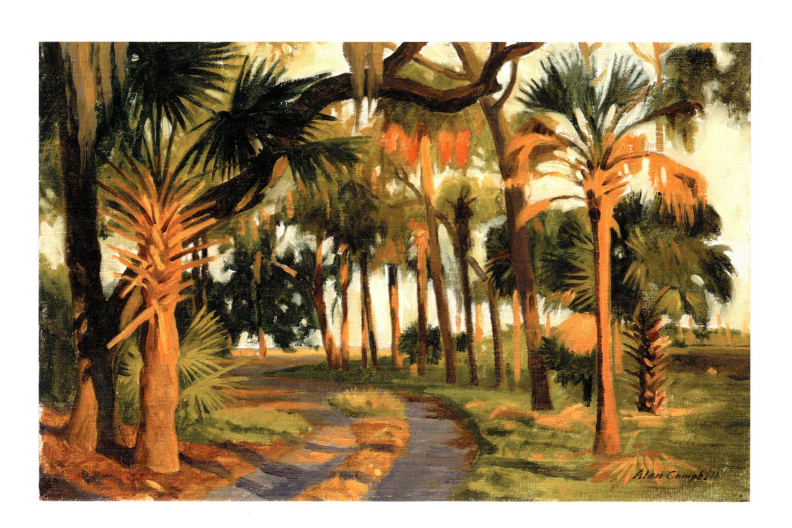

DEEP WOODS

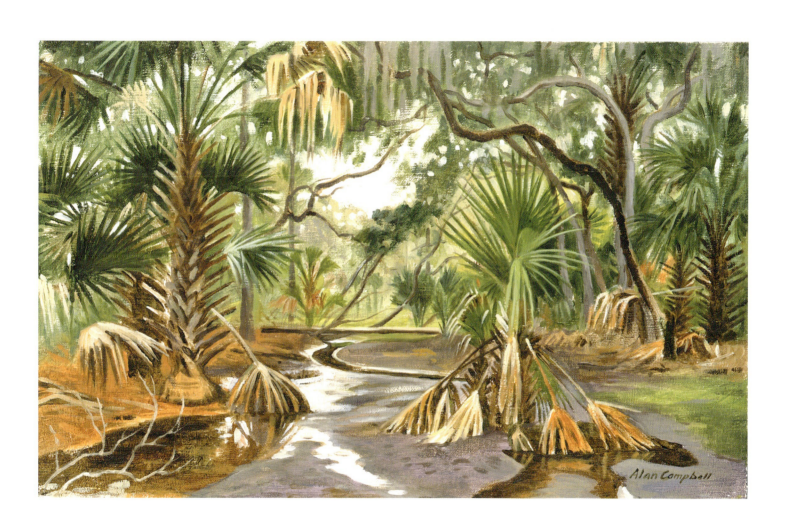

DUNE PALMS

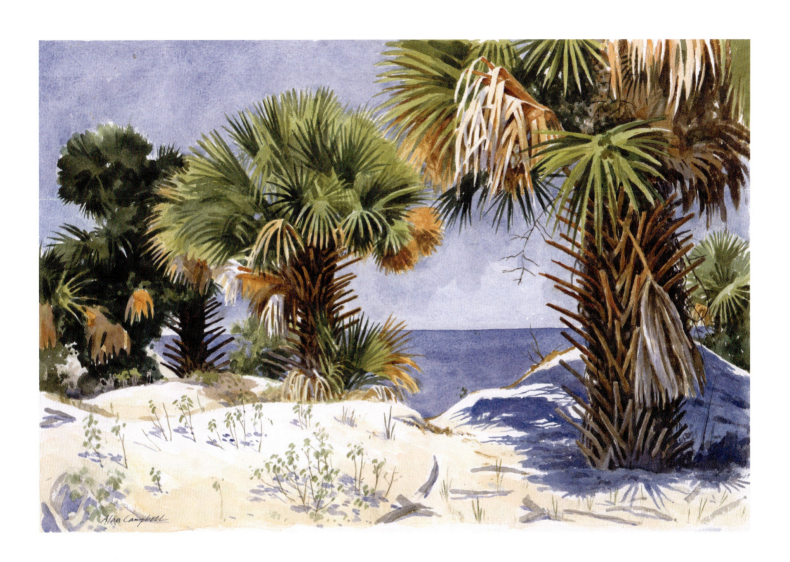

EBB TIDE

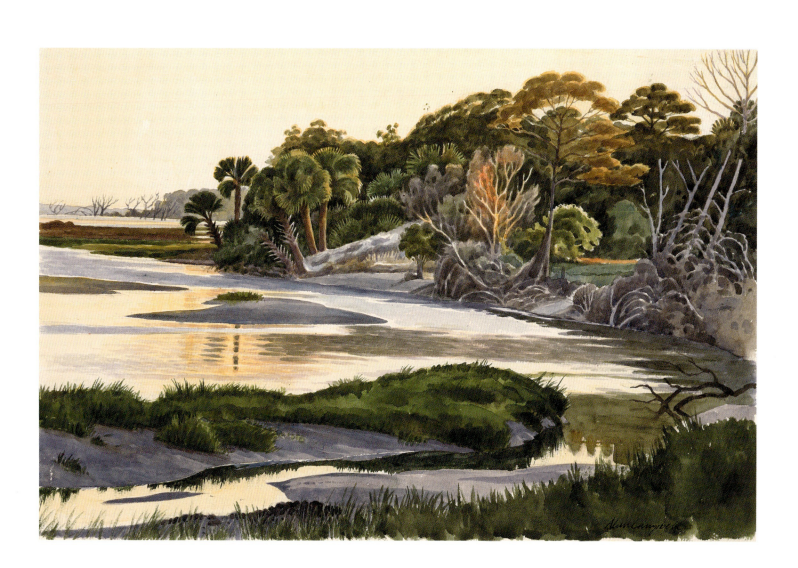

MARSH FENCE

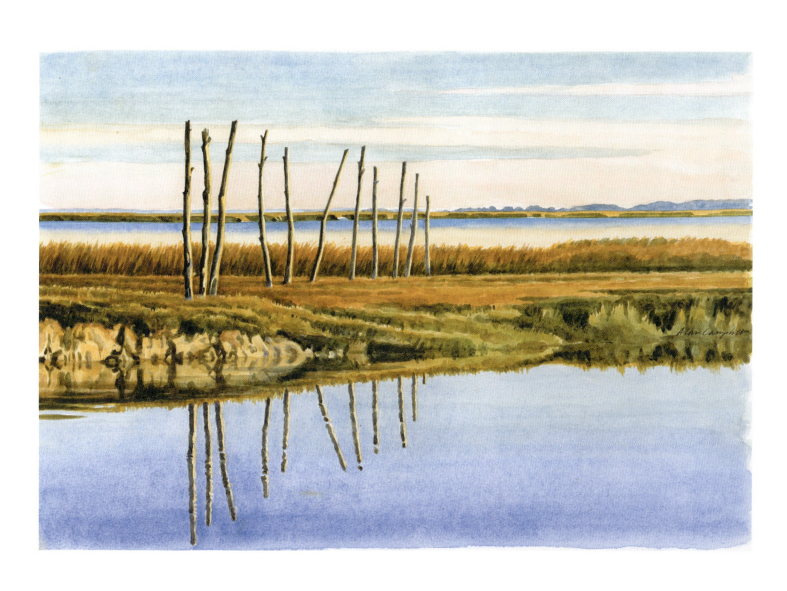

GHOST

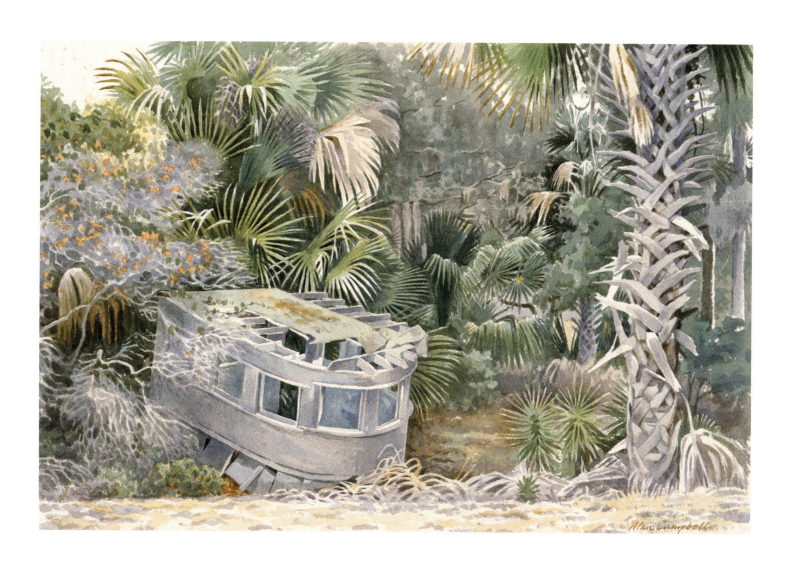

HAINT'S HAUNTING

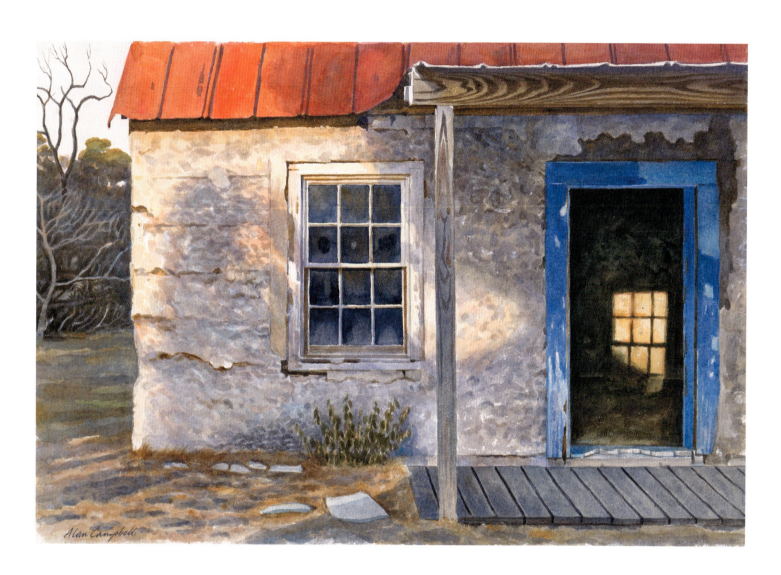

MARSH POND

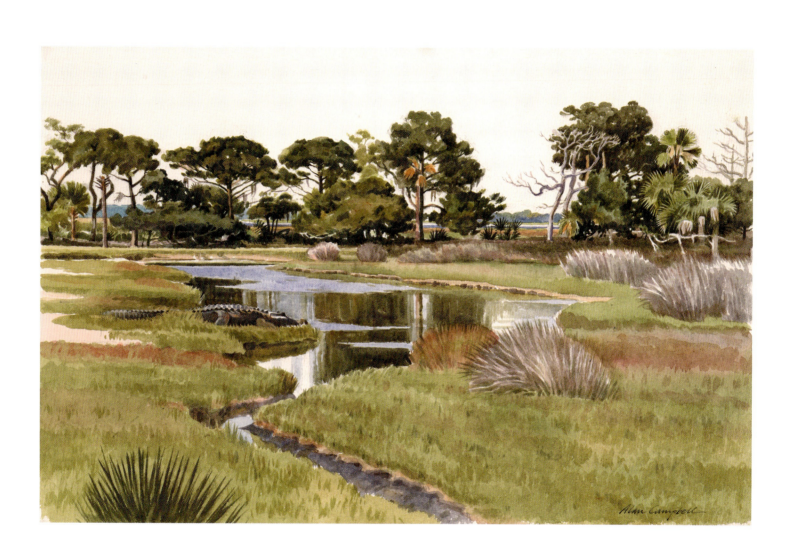

OLD OYSTER HOUSE

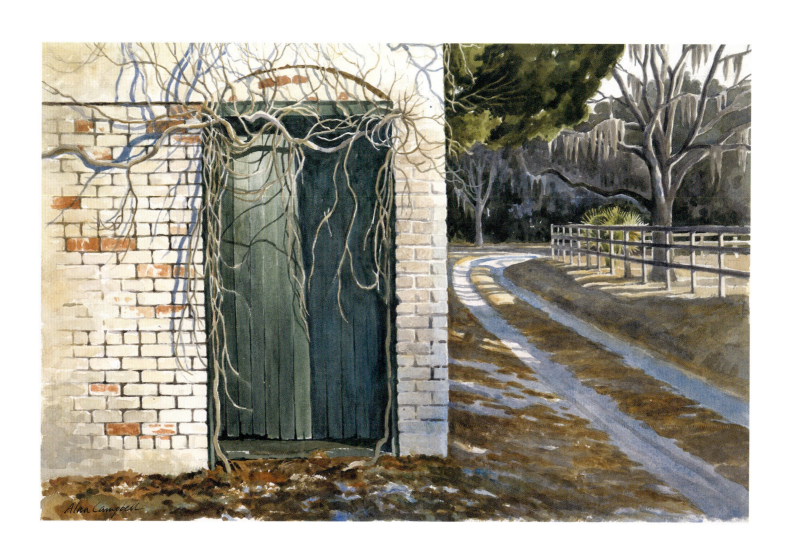

OSSABAW OXBOW

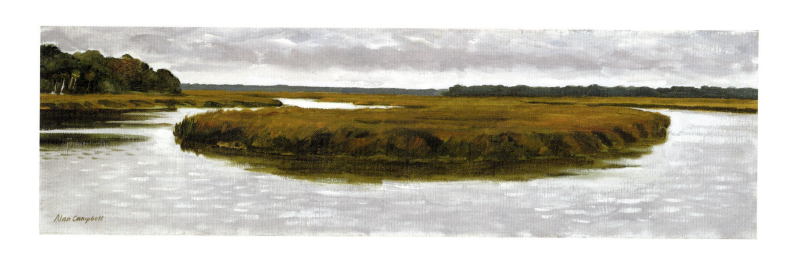

PALM FOREST

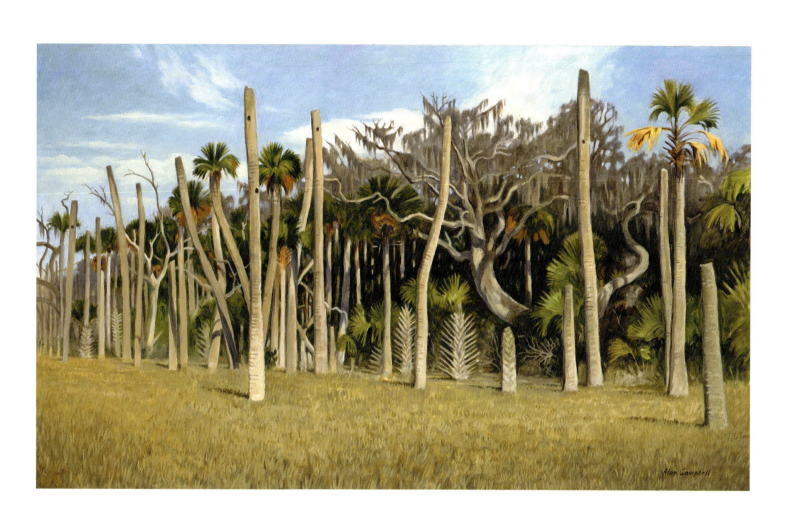

SKELETON TREES

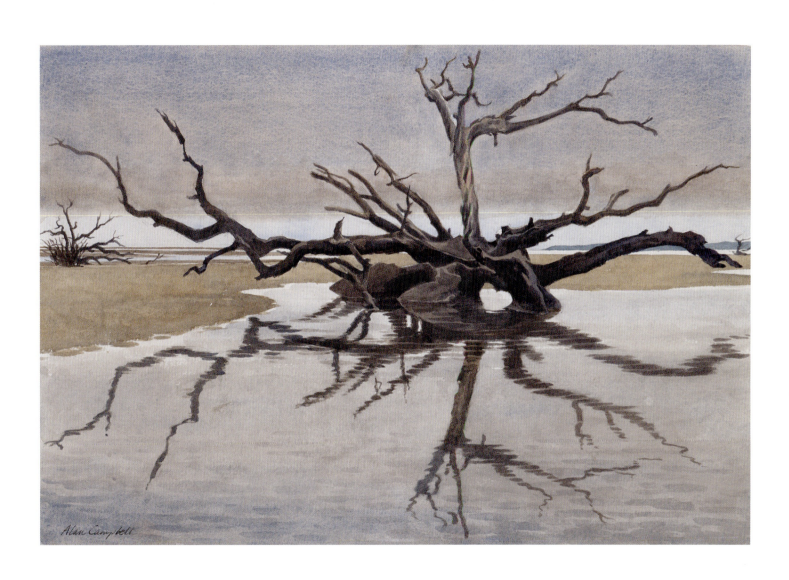

SOUTH BEACH ROAD

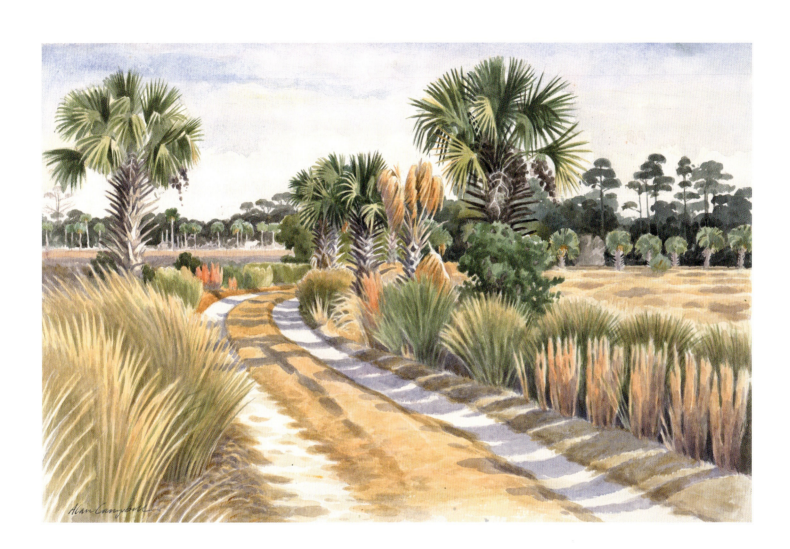

THE GREAT OAK

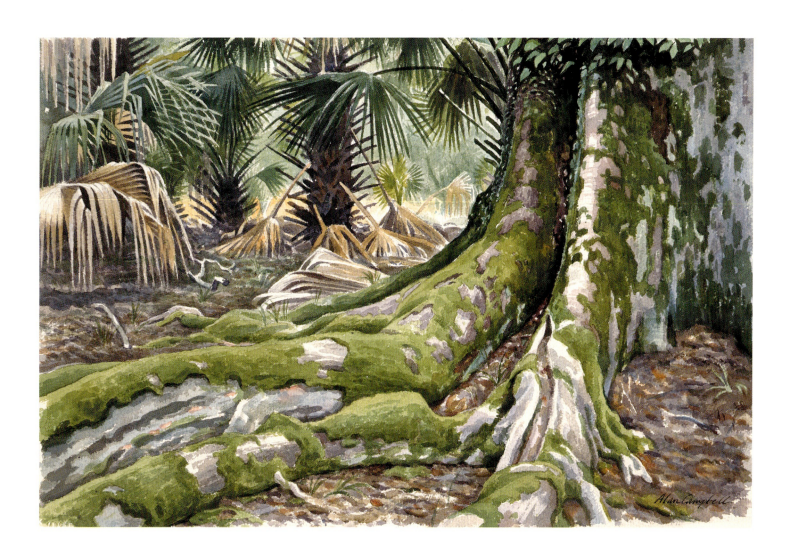

TIDAL CREEK

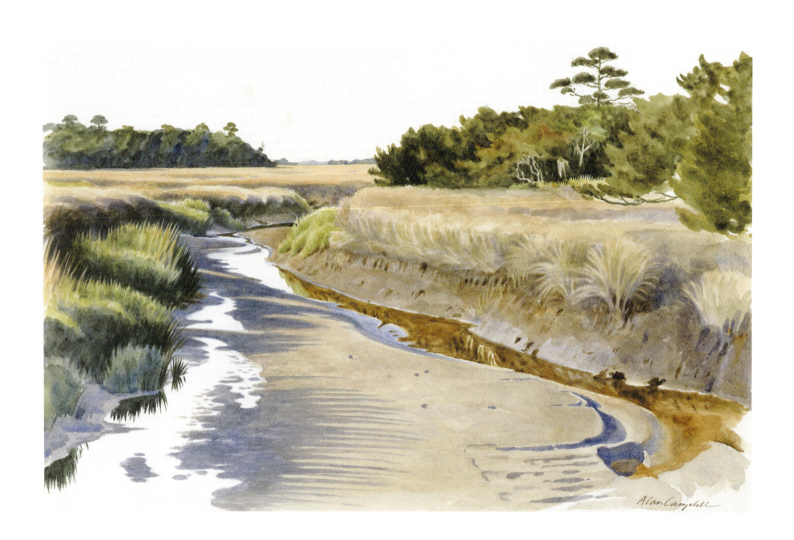